The Art of Stencil Embossing

Janet Wilson

SEARCH PRESS

First published in Great Britain 2000

Search Press Limited
Wellwood, North Farm Road, Tunbridge Wells,
Kent TN2 3DR

Reprinted 2001, 2004, 2005, 2006

Text copyright © Janet Wilson 2000

Photographs by Search Press Studios
Photographs and design copyright © Search Press Ltd. 2000

ISBN 0 85532 841 X

Readers are permitted to reproduce any of the items/patterns
in this book for their personal use, or for the purposes of
selling for charity, free of charge and without the prior permission
of the Publishers. Any use of the items/patterns
for commercial purposes is not permitted without the prior
permission of the Publishers.

The Publishers and author can accept no responsibility for
any consequences arising from the information, advice or
instructions given in this publication.

Suppliers
If you have difficulty in obtaining any of the materials and
equipment mentioned in this book, then please visit the
Search Press website for details of suppliers:
www.searchpress.com
Alternatively, you can write to the Publishers at the address
above, for a current list of stockists, including firms who operate
a mail-order service.

With many thanks to:
Clarity Stamps, UK; Daler-Rowney Ltd., UK, for the lightbox;
Design Objectives, UK; Dhondt BVBA, Belgium;
Dreamweaver Stencils, USA; Kars & Co. b.v., The Netherlands;
PME (Harrow) Ltd., UK; Ranger Industries, Inc., USA;
Staedtler (UK) Ltd.; The C-Thru Ruler Company, USA.

Special thanks to:
Fanny Ong (USA) and Freda Rudman (UK), for their help with
the background research.
Lynell Harlow of Dreamweaver Stencils.
Carole and John Dalton, for their wonderful hospitality
(once again) during photography.

Publishers' note
All the step-by-step photographs in this book feature the
author, Janet Wilson, demonstrating her stencil embossing
techniques. No models have been used.

Colour separation by Graphics '91 Pte Ltd, Singapore
Printed in Malaysia by Times Offset (M) Sdn Bhd

Janet Wilson has lived and breathed
papercrafts since early childhood, when she
was first given a pair of scissors and some
paper to keep her occupied. Since then,
she has become proficient in a wide range
of paper skills including parchment craft,
quilling, paper cutting, embossing, paper
pricking, casting and sculpting. Other
outside interests involve her in amateur
dramatics, especially in the fields of music
hall and costume design.
Janet lives in Berkshire with her Shih Tzu
dog, Blackie. She is also the author of the
best-selling books *Parchment Craft*, *The Art
of Parchment Craft*, *The Craft of Quilling*
and *The Art of Decorative Paper Pricking*, all
published by Search Press.

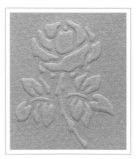

*With love and thanks to Dorothy Hughes, for
being a wonderful, honest and supportive
friend for many years; to TS, who is PD for
once again keeping the flame of my creativity
burning brightly; and to SB, for guiding me.*

Contents

Introduction 4

Materials 6

Embossing pale paper 10

Intaglio images 18

Corner borders 22

Embossing opaque paper 28

Embossing metal 34

Fancy-edged rulers 42

Moving on 47

Index 48

Introduction

Embossing - the process of raising or depressing a design

In historical terms, stencil embossing on paper is a relatively recent innovation, but it combines two much older art forms – stencilling and embossing.

There is lots of evidence to suggest that stencils have been used to impart decorative designs on to many different surfaces since the days of the Ancient Egyptians, 4,500 years ago. Early Chinese, Greek and Polynesian artists used stencils, and Buddhist temples have been decorated with them for thousands of years. In Europe, before the invention of the printing press, stencils were used to produce religious manuscripts. They were also used during the Middle Ages to decorate church walls, floors and furniture.

Mechanically embossed images are much used today by the greetings card industry. Embossed cards became very popular during Victorian times when ladies would have a box of extremely ornate writing paper with embossed surrounds, and matching envelopes, which they used to send birthday greetings and thank you letters. Heavily embossed, black-edged stationery was also favoured by Victorians, as were pastel-coloured wafers that had delicate white raised designs in the centre. The production method used today is still much the same as in earlier times. A sheet of paper is pressed between a hard 'block' – originally carved in wood, but now made from more modern materials – and a relatively soft 'blanket'. Pressure is applied to the block and the design is impressed into the back of the paper to create an embossed image on the front.

In this book I show you how you can use stencils in a variety of ways to produce many exciting effects. There is a tremendous choice of stencils available. Brass stencils, produced specifically for embossing paper, have designs to suit all tastes and preferences, but you can also emboss with stencils that are made for decorating fabrics, walls and even cakes! I have also included a number of finished designs which I hope you will find inspirational. Stencil embossing is very versatile and lends itself to mixing with other paper crafts so, go on, be creative, experiment, mix and match and, above all, enjoy yourself.

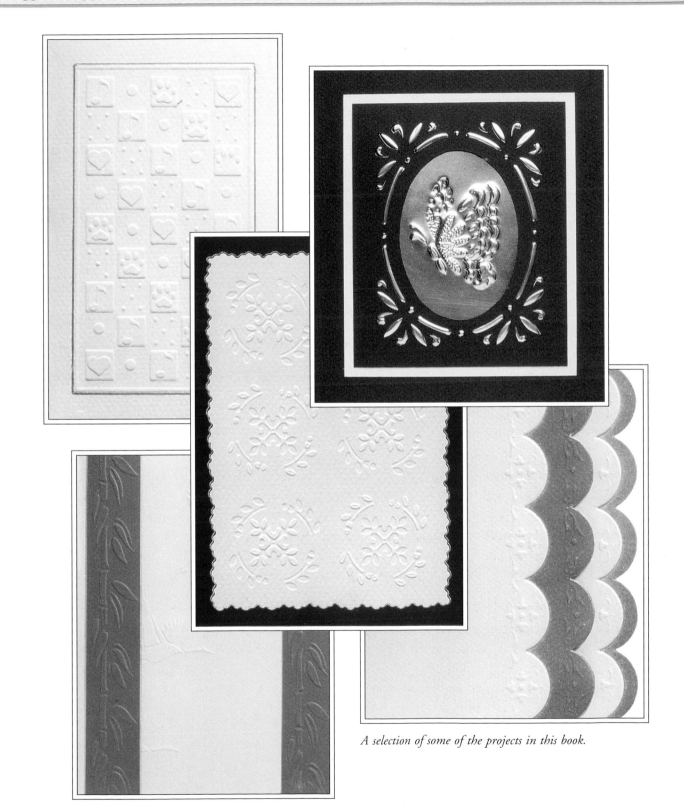

A selection of some of the projects in this book.

Materials

Some paper, a stencil, an embossing tool and a source of light are all you need to get you started on stencil embossing. As you get more and more into the craft, you can add other materials and equipment to your tool box.

Paper

You can buy special embossing paper, but there is a whole host of other papers on the market that can be embossed with stencils. My favourite is a textured paper developed for soft pastel artists. This is available in a wide range of pale tints, as well as a full spectrum of darker colours, and reacts very well to embossing tools. I also use good quality note paper, velvet paper (for a softer, subtle effect), metallic art paper and virtually anything else that gives me good results.

Many years ago I went on a silversmithing course and this gave me a great love of metal. You can also use stencils to emboss on sheets of metal foil and tooling foil to give your work another dimension.

Before starting a project, I always test samples of new materials to ensure they are suitable for embossing. Some thin papers, for example, tear easily. On the other hand, it can be difficult to make good clear impressions on thick papers. Some dark colours emboss better than others.

If the paper you want to use for the basic card is difficult to emboss, use a layering technique to complete a project. Emboss your design on to a suitable paper, cut it out and then mount it on to your card paper. Layering can also be used to introduce colour in the form of decorative papers.

Strong dark colours have their uses, but do test them before starting a project. I also emboss on sheets of metal foil and tooling foil.

Pale tints of textured soft pastel paper are ideal for stencil embossing.

Embossing tools

Embossing tools are available from good craft shops. Most are double-ended with a different-sized metal embossing tip fitted to each end of a wooden handle. You can also buy plastic tools with large embossing tips. A needle tool is a useful addition to your tool box.

Stencils

Many different types of stencils can be used to emboss paper, and there is a wide range of subjects to choose from.

Brass stencils are designed specifically for paper embossers, but you can emboss through coloured plastic and acetate stencils that are normally used for stencil decoration on walls, fabrics and cakes. You can also cut your own stencils from coloured sheets of acetate (see below). Aperture templates (often used for making memory books and other crafts) are useful for creating raised areas in which other motifs can be worked. You can even use the apertures found on some card 'blanks' as embossing stencils.

Some stencils have multiple motifs while others have a complete design. Be selective when choosing your stencils – look at the component parts of each stencil, not just the overall design. You will find that you can mix and match motifs from just a few stencils to build up a whole host of different designs.

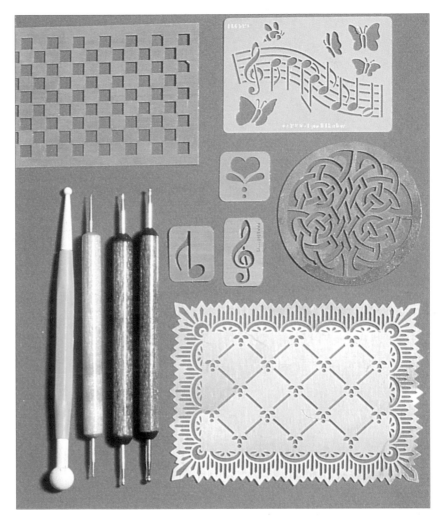

Selection of brass stencils and embossing tools.

Cutting your own stencils

You can create your own stencil designs, then use an electric stencil cutter to cut them out of sheets of coloured acetate (see page 38). You need a coloured stencil so that the outlines of the cut image will show up on the lightbox. Protect your work surface with a piece of thick glass.

Fancy-edged rulers

These are normally used to draw decorative borders, etc. in memory albums, but they can be used to emboss some very interesting designs (see page 42).

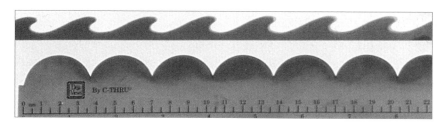

Fancy-edged rulers are available in lots of different shapes.

Lightbox

Back lighting the stencil, so that its outlines can be seen through the paper, makes embossing on pale, translucent papers very easy. Small portable lightboxes are readily available, and are ideal for the embosser. I do not know what I would do without mine as, apart from embossing and transferring designs on to the card paper, I find it useful for lots of other things.

A small portable lightbox makes embossing on pale colours very easy.

You could make a lightbox by placing a lamp under a glass-topped table. If you use this method, place a piece of milk glass or a sheet of tracing paper on the table glass. This will diffuse the light and ensure you do not damage your eyesight. During daylight hours, of course, you could use a window as a lightbox.

If you do not have a lightbox, you could use the embossing mat technique (see right). Alternatively, you can tape together two identical stencils, one on top of the other, and slip a piece of card paper between them. Then, using the top stencil as a guide, you emboss the card paper into the bottom stencil and, hey presto, you have a raised image.

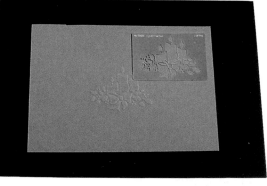

An embossing mat is used to emboss opaque papers and metal foil.

Embossing mat

A lightbox does not work when embossing opaque papers and metallic surfaces, so another technique must be used. This involves working on a embossing mat, and using a fine embossing tool to lightly impress the outlines of the stencil into the paper. When the paper is turned over, a slightly raised image is revealed – this is then used as a guide to emboss the motif (see page 28). My mat is a piece of high-density foam which has the right amount of 'give' for embossing.

Other equipment

The following is a list of other equipment I use when drawing up plans and assembling the finished pieces.

Craft knife I use this for cutting straight lines and intricate shapes.

Steel-edged ruler A good investment for any craft – the steel protects the straight edge when cutting with a knife.

Cutting mat A self-healing surface on which to cut paper with a craft knife

Pencils I use a graphite pencil with pale coloured papers and a white pencil with dark colours.

Scrap paper For drawing plans.

Set square Ideal for squaring up the edges of the finished cards.

Spray adhesive Use a low-tack adhesive for layering fragile papers, and normal adhesive for others.

Masking tape This is ideal for temporary fixings.

Double-sided sticky tape An alternative to spray adhesive when layering sheets of paper.

Beeswax Use this to grease embossing tools when working on metallic surfaces.

Paper cutting scissors For cutting apertures and masks to embellish embossed designs.

Fancy-edged scissors These are available in a range of designs. I use them to create decorative edges round embossed designs.

Pens I use metallic gel pens to define borders and embossed motifs.

Decorative papers Layered with embossed designs, these add colour and texture to a project.

Dye ink pads These are ideal for creating smooth blocks of colour. They are available in a range of colours and dry very quickly.

Sponge I use this for applying dye ink.

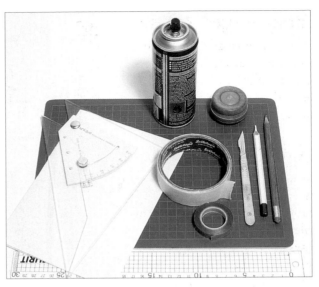

A cutting mat, craft knife, steel-edged ruler, set square, scrap paper, spray adhesive, masking tape, double-sided tape, pencils and a wax pot are all useful additions to the tool box.

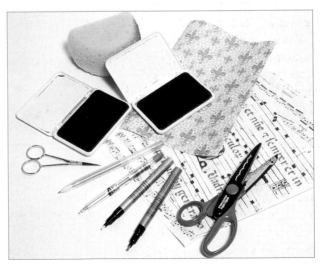

Dye ink pads and a sponge, decorative paper, paper cutting scissors, gel pens and fancy-edged scissors can all be put to good use with embossed motifs.

Embossing pale paper

For this first project, I take you through the stages of creating a folded card that has an embossed design on the front face. First, you should draw up a plan of the intended card. A plan may seem unnecessary when embossing from a single stencil but it is particularly important when you use elements from different stencils to make up a design. Next, you must indicate (but not crease) the intended fold line, make a pencil mark on the inside front cover of the card paper, then transfer the plan to the inside front cover. Embossing the design comes next – do not press too hard or you will tear the paper. Finally, you fold and trim the finished card to size.

Simple folded card

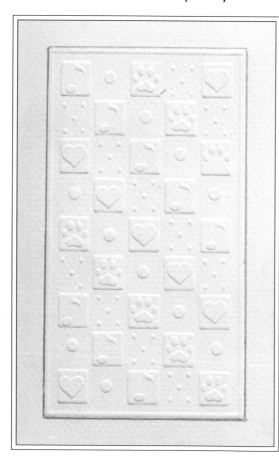

I used three stencils to create this folded card: a grid stencil to create raised squares; a multi-image stencil for the small motifs; and a straight line one for the border. I extended the grid design to give three squares at the bottom to match those at the top. I used a gold gel pen to define the edge of the border.

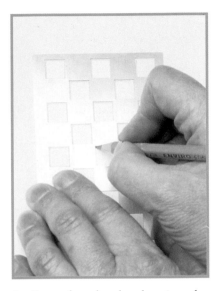

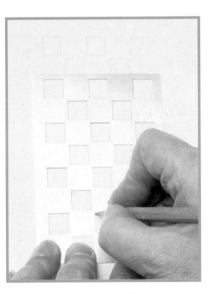

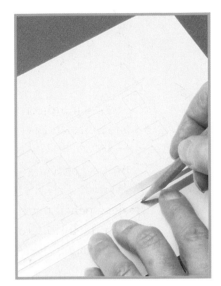

1. Start the plan by drawing the squares of the grid stencil on to a piece of scrap paper.

2. Realign the stencil over the drawn grid, then pencil in the bottom three squares.

3. Use a straight line stencil to mark the border.

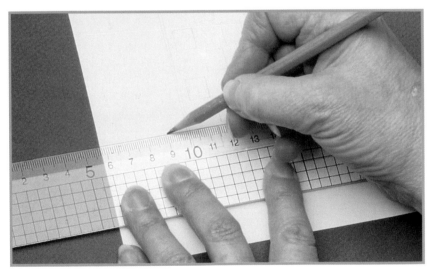

4. Complete the plan by marking the outer edges of the card.

5. Place the card paper face down on the work surface, fold one side over, then make a short crease in the middle of one of the long edges. Use a pencil to lightly mark the inside front of the card .

Cleaning stencils

If you do not clean all traces of pencil lead from the stencils before using them to emboss your design, you will find dirty marks on your embossed paper. Graphite is easily removed with a piece of kitchen paper or a soft cloth.

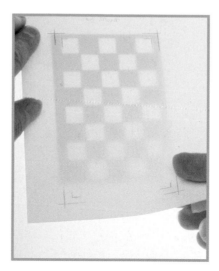

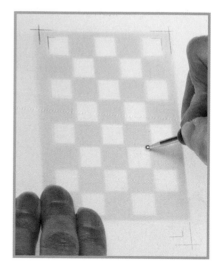

6. Place the plan on a lightbox, locate the card paper (face down) on the plan and align the fold edge. Use a pencil to transfer the plan on to the inside front of the card paper.

7. Secure the grid stencil to the lightbox. Place the front of the card (face down) over the stencil and align the tops of the plan and stencil. Secure the card with masking tape.

8. Gently run a large embossing tool round the outline of each square of the stencil, and notice how each square of paper becomes impressed into the shape of the stencil.

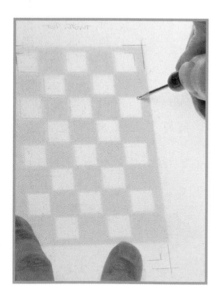

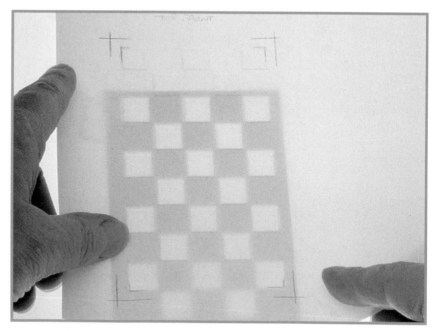

9. Now, using a medium embossing tool, go round all the squares to sharpen up the edges.

10. Carefully reposition the bottom of the card paper over the stencil, then repeat steps 8–9 for the bottom three squares.

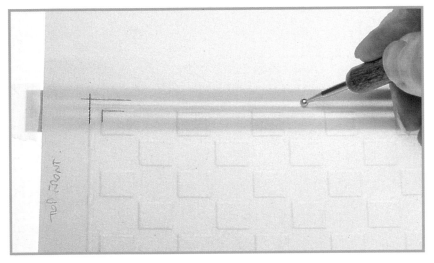

11. Use a straight line stencil and the large embossing tool to create the raised border round the grid design. Take care to align the stencil correctly at the corners.

12. Use the detail stencil to emboss small images on diagonal rows of raised squares. Here, I am embossing a small heart.

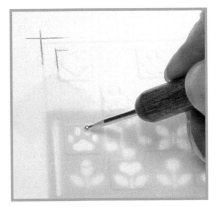

13. Emboss the second motif (a paw print) on the raised squares in the next diagonal row.

14. Emboss a third motif (a musical note) on the squares in the next diagonal row. Repeat steps 12–14 until all the raised squares have been embossed.

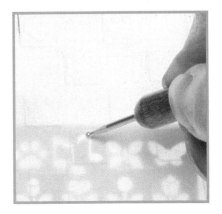

15. Now emboss a diagonal row of five dots in the spaces between the raised squares.

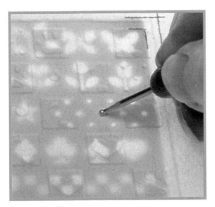

16. Emboss small circles (from one of the flower images) in the next diagonal row. Repeat steps 15–16 until all remaining spaces have been embossed.

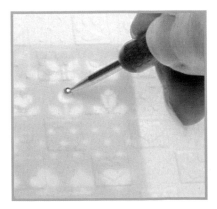

17. Place the card (face down) on a cutting mat, align a straight edge along the fold line, then use a fine embossing tool to crease the fold.

18. Fold the card along the crease, then use a set square and a craft knife to trim the folded card to its finished size.

19. Finally, use a gold gel pen to outline the embossed border.

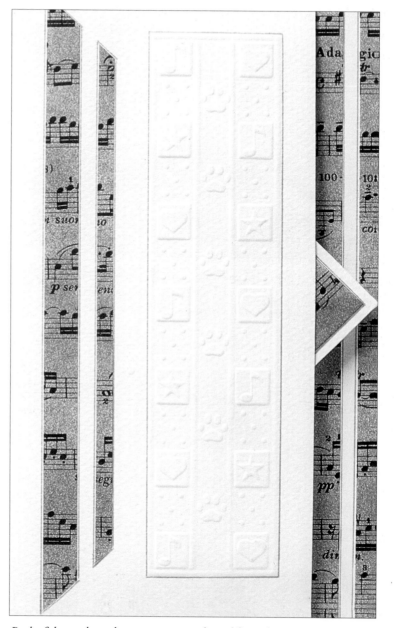

Both of the cards on these pages were embossed from the same three stencils used for the project on pages 10–14.

This design is a simple folded card with a triangular flap attached to the narrow front face.

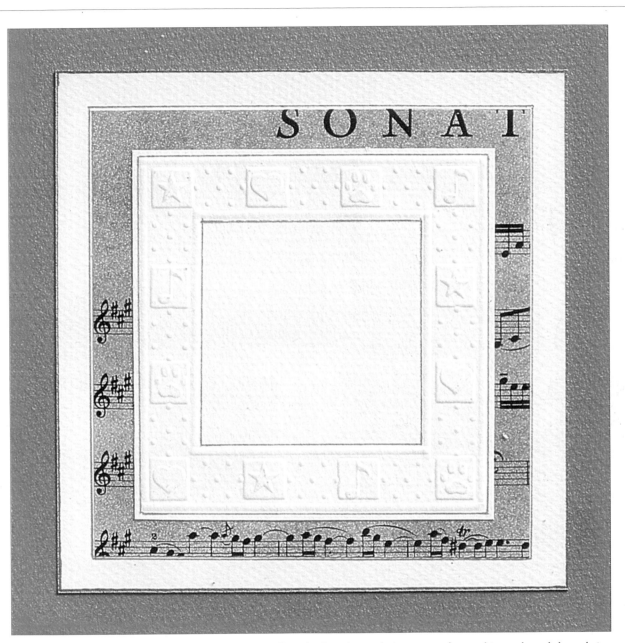

I used a layering technique to make up this card; each layer being 5–10mm (¼–½in) larger all round than the previous one.

The decoration on both cards is cut from a sheet of Italian art paper. Its pattern of musical notes is just one of many lovely designs you can use for embossing projects. The original background colour of this particular paper was cream but, with the aid of a dye ink pad and a sponge (see page 43), I customised it to suit my purpose.

Here are some more card designs embossed with different stencils. Again, I layered the embossed images on contrasting paper to make the finished cards.

For the card above, I used part of a wall stencil. I embossed the top half first, then flipped the stencil over to create the bottom half. Small motifs from other stencils were then added to achieve the finished effect.

A simple square border stencil formed the frame for the floral card (above right).

I used one stencil to emboss both images on the card (right). I worked the image on one panel, then turned the stencil over for the other. Two peel-off butterflies complete the card.

This Christmas card is worked on white velvet paper which gives it a lovely soft effect – just right for snow scenes such as this. The embossing was layered with matte gold and dark green papers on to a white card. A paper-punched snowflake in each corners provides the finishing touch.

I cut these luggage-style labels out of green art paper and added reinforcing rings on both sides of the punched hole to give them a more authentic appearance. I then layered embossed panels on the background. Messages can be written on the back of the label with a gold gel pen. If you have ready-made manila labels in stock, you could use a dye ink pad and a sponge to colour them (see page 43).

Intaglio images

In the first project all the embossing was from the back of the card paper to produce cameo (raised) designs. However, you can also emboss parts of a design from the front of the card paper to create intaglio (impressed) images. This effect gives a different slant to a simple design and adds texture and dimension. When embossing on the front of the paper you must be careful not to allow the embossing tool to slip off the design and create a mark in the paper. Such a slip does not matter when embossing on the back of the paper as it does not show.

Layered, repeat pattern

Here, I used a single stencil to create a repeat pattern. For each stencil design, I worked parts of the image from the back of the card paper and others from the front. Notice that I also reversed the embossing on alternate rows. The embossed image is layered on to a contrasting blank card. You could turn this design through 90º and make the fold on the short side.

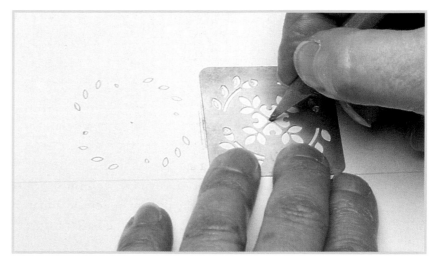

1. Before drawing your plan, try out the stencil on a piece of paper, working some images from the front and some from the back. Decide on which parts of the image you want to appear as cameo or intaglio.

2. Start drawing a plan by tracing the outer part of the stencil and its centre point. Decide on an appropriate space between the motifs, then mark the centre of the second motif. Measure the distance between the centres and use this to complete the plan. Transfer the plan on to the back of the card paper.

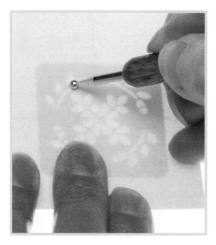

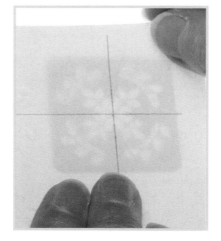

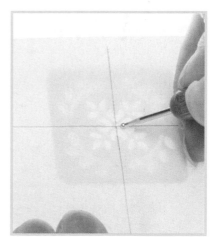

3. Secure the stencil to the lightbox and position the card paper (face up) on the stencil. Use the large embossing tool to start embossing all the intaglio images, then work the same areas with the medium tool to sharpen them up.

4. Remove the card paper, turn the stencil over and secure it to the lightbox. Place the card paper (face down) over the stencil and align the embossed intaglio images with the stencil.

5. Now work all the cameo images using the large and medium embossing tools. Repeat steps 3–5 for the other segments of the design.

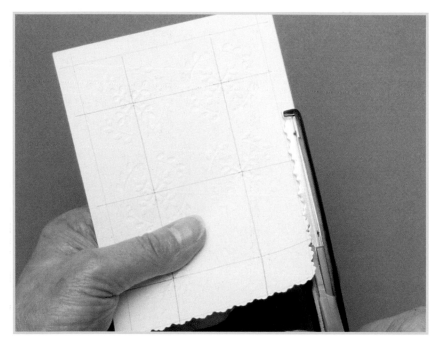

6. Draw guide lines to represent the outer edges of the card, then use fancy-edged scissors to create a shaped edge.

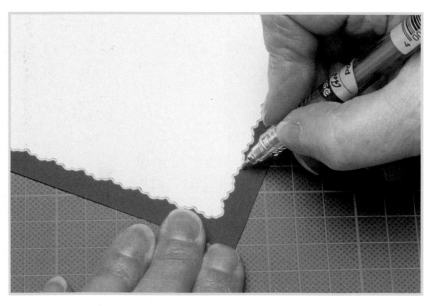

7. Use spray adhesive to secure the embossed image on to your card, then carefully run a gold gel pen round its fancy cut edge (letting the pen follow the contours) to emphasise the shape.

All these designs are worked in cameo and intaglio.

To create added interest to the bookmark (opposite) and the initialled card (above), I used a long-reach paper punch to remove the middle of each embossed flower.

For the bookmark (above right) and the heart card (right), I used fancy-edged scissors to create the outer edges of the backing paper. I then embossed the image on contrasting paper and layered this on top of the backing paper.

Corner borders

There is nothing quite as useful as an embossed border to add dimension to your designs. Many stencils have corner designs which can be extended into complete borders. In this chapter, I have included two projects – the first has a simple, straight line corner border, while the other is more complex. Simple corner borders (with straight lines forming the sides) can be extended to fit any size of plan. However, for more complex borders (with a repeat pattern), you must take care to size the plan accordingly.

Simple corner border

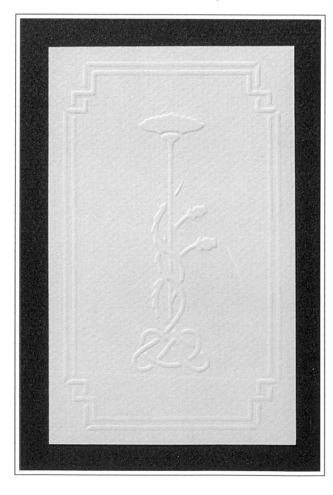

The simple, straight line corner border used for this card can be extended to fit any size of plan. First, I traced round the outside edges of the stencil for the central motif, then developed the rest of the design. When extending straight lines, do not emboss right up to the very end of the cutout, as this may create a sharp edge. Such edges can be difficult to disguise when you come to join up the lines.

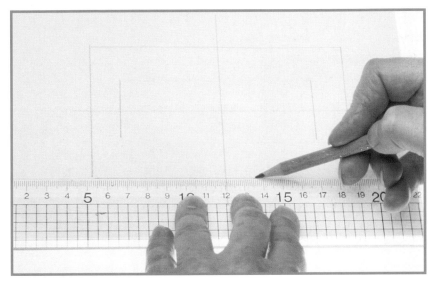

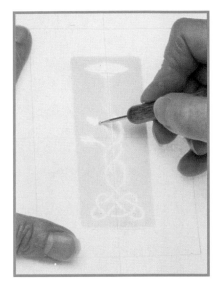

1. Use the stencils to help draw up a plan of the design, then use the lightbox to transfer it on to the back of the card paper.

2. Fix the stencil for the central motif on the lightbox. Align the card paper (face down) over the stencil, then emboss the image.

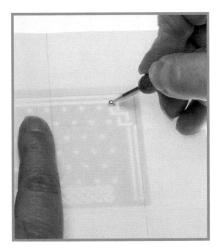

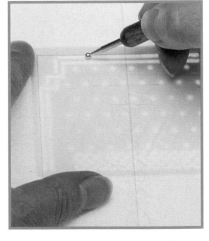

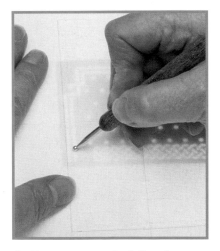

3. Secure the corner stencil to the lightbox, then locate the top right-hand corner of the border over the stencil. Use the large embossing tool to work the corner design, making the sides as long as necessary. Remember not to emboss to the very end of the cutout.

4. Remove the card, turn the stencil over, locate the top left-hand corner of the border over the stencil, using the embossed side lines as guides, then emboss this corner and its extensions.

5. Repeat steps 3–4 for the bottom two corners, then carefully join up the long sides of the border. Cut the embossed sheet to size, then use spray adhesive to layer it on to the contrasting blank card.

Complex border

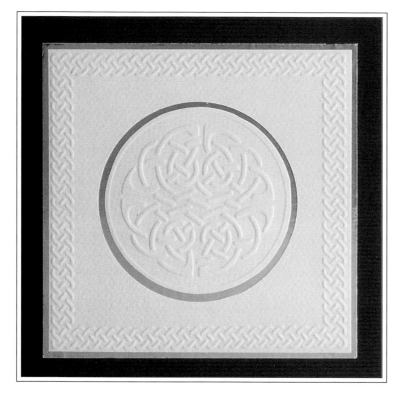

The Celtic corner border selected for this card has a repeat pattern. This type of design can be extended, but you must pencil reference marks through the stencil to arrive at the finished size. You may have to make your design slightly smaller or larger than you intended. I layered the embossed images with a piece of gold metallic paper on to the blank card.

1. Draw a square roughly the size you want the border to be, extending the lines at the corners. Place the stencil exactly over the top right-hand corner of the square, then pencil in a few register marks through the corner of the design.

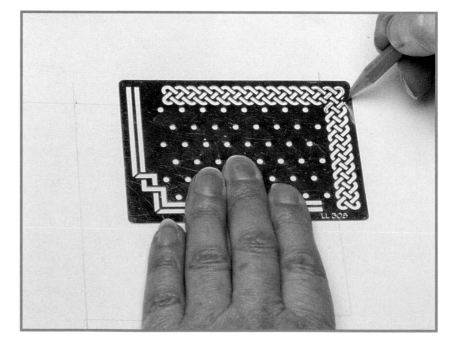

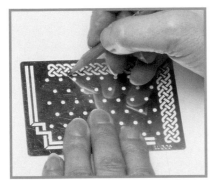

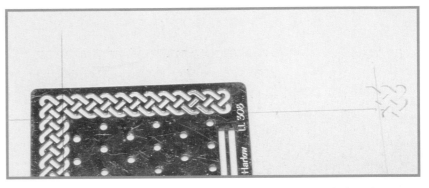

2. Without moving the stencil, make more register marks just short of each end of the design.

3. Turn the stencil round 90º, align it with the top left-hand corner of the square, then check the register marks made in step 2. Unless you have been extremely lucky, they will not match, so realign the stencil to match the register marks (here I decided to make the border slightly smaller than the original).

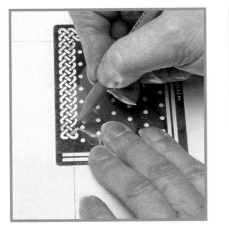

4. Make more register marks at the bottom of the long side.

5. Repeat steps 3–4 for the other two corners. Erase the original lines, then use the register marks to redraw the border on the plan.

6. Transfer the plan on to the back of the card paper, then emboss the border corner by corner.

7. Carefully cut a circle in the centre of the card. Emboss the central motif, then cut it out. Finally, layer the two embossed images and the gold metallic paper on to the blank card.

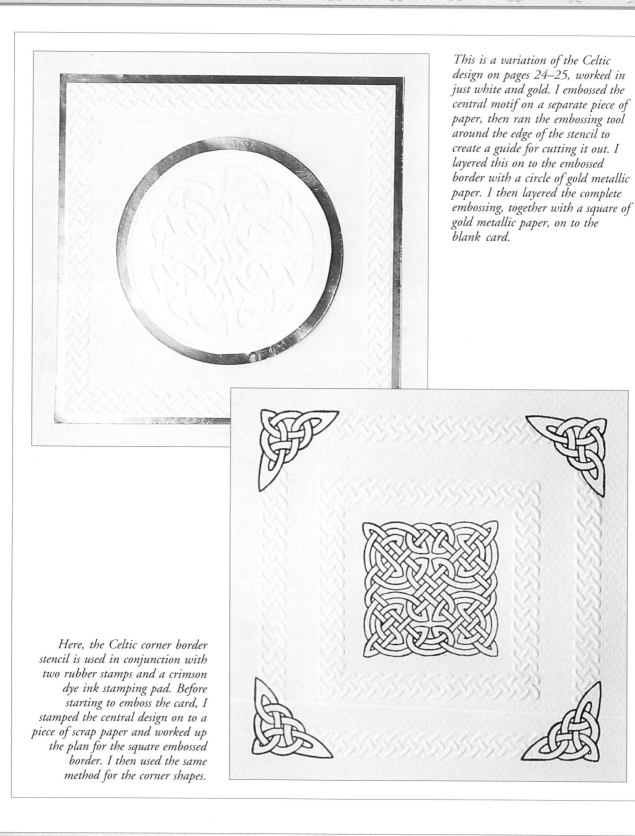

This is a variation of the Celtic design on pages 24–25, worked in just white and gold. I embossed the central motif on a separate piece of paper, then ran the embossing tool around the edge of the stencil to create a guide for cutting it out. I layered this on to the embossed border with a circle of gold metallic paper. I then layered the complete embossing, together with a square of gold metallic paper, on to the blank card.

Here, the Celtic corner border stencil is used in conjunction with two rubber stamps and a crimson dye ink stamping pad. Before starting to emboss the card, I stamped the central design on to a piece of scrap paper and worked up the plan for the square embossed border. I then used the same method for the corner shapes.

Brass stencils are extremely versatile, and I used just two stencils to create this design. The border is embossed from the same corner stencil that was used for the bookmark on page 21. This stencil also includes a lattice design (which I used to emboss the diagonal lines) and a floral motif. I decided to omit these flowers and replaced them with some of the flowers and leaves that appear on the stencil used for the intaglio project (see pages 18–20).

For this card, I used the same straight border stencil from which I created the bookmark on page 20. Here I used it to plan each side of the design, then turned the stencil through 45º to create the corners. The central bird bath was worked as cameo and intaglio to make it more three-dimensional.

Embossing opaque paper

Dark or opaque papers cannot be embossed on a lightbox, so a different embossing technique must be used. The card paper is placed (face up) on an embossing mat and the stencil is secured to the paper with low-tack adhesive. A fine embossing tool is then used to carefully trace the outlines in the stencil and create a slightly raised image on the back of the paper. Leaving the stencil in place, the paper is turned over and you emboss within slightly raised areas.

Repeat opaque design

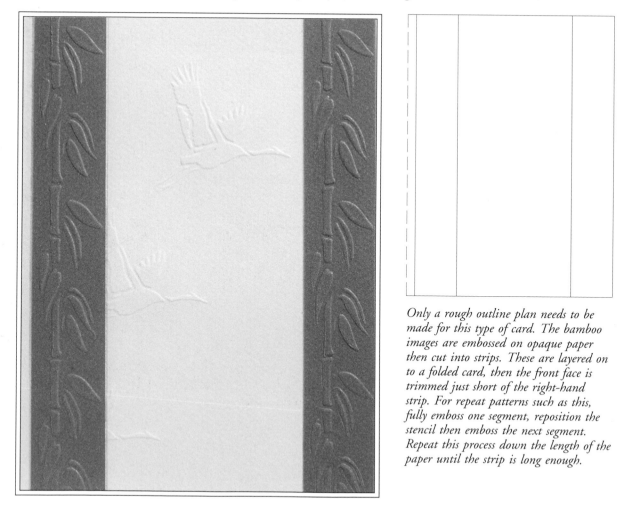

Only a rough outline plan needs to be made for this type of card. The bamboo images are embossed on opaque paper then cut into strips. These are layered on to a folded card, then the front face is trimmed just short of the right-hand strip. For repeat patterns such as this, fully emboss one segment, reposition the stencil then emboss the next segment. Repeat this process down the length of the paper until the strip is long enough.

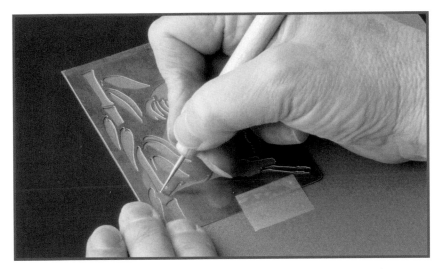

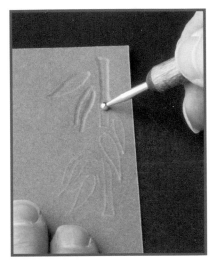

1. Place the opaque paper (face up) on the embossing mat, then secure the bamboo stencil against one edge. Use a fine embossing tool to lightly impress the outline of the design into the paper. Note that to achieve a repeat pattern I do not use the bottom few cutout shapes on the stencil.

2. Leaving the stencil secured to the paper, turn the work over and use a large embossing tool to emboss within the visible raised areas of the motif.

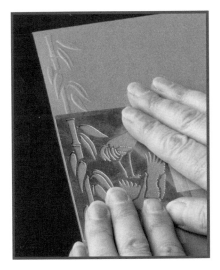

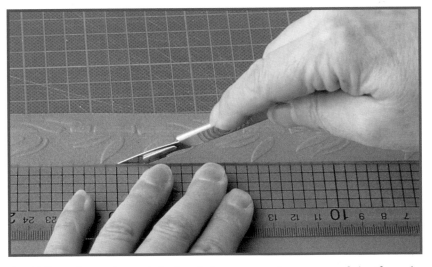

3. Turn the work over again, realign the stencil to extend the design, then repeat steps 1–3 down the length of the paper.

4. When the embossed design is long enough, use a craft knife and a steel-edged ruler to trim the strip to its final width. Repeat steps 1–3 to make the second strip.

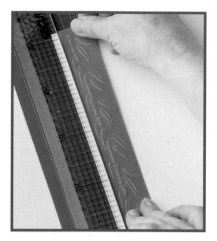

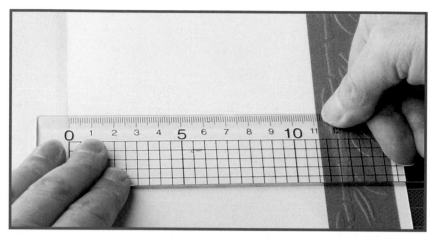

5. Fold the card paper in half, then layer one of the embossed strips to the left-hand side of the front of the card. Use a ruler to align the strip to the fold edge.

6. Open the card, then fix the second blue strip to the right-hand inside face, aligning it against the outside edge of the card. Measure the distance from the fold to the inside edge of the blue strip.

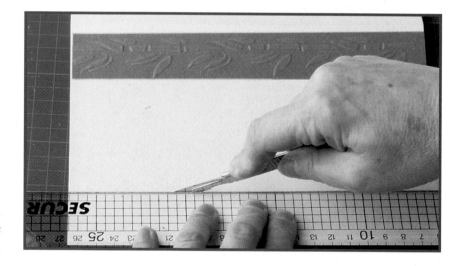

7. Turn the open card over, then cut the front face to the measurement taken in step 6.

8. Use a gold gel pen to draw lines down the sides of each of the two blue strips. Trim off excess paper from the back of the card, then use a set square to trim the top and bottom.

9. Finally, use the lightbox to emboss the birds on to the front face of the card paper.

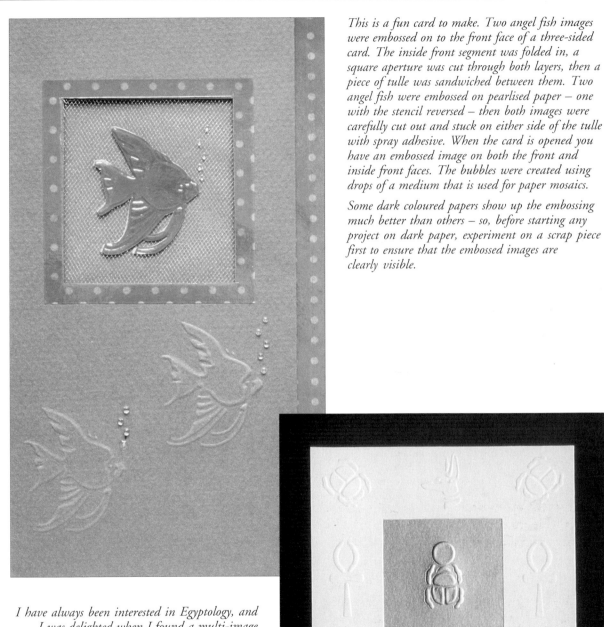

This is a fun card to make. Two angel fish images were embossed on to the front face of a three-sided card. The inside front segment was folded in, a square aperture was cut through both layers, then a piece of tulle was sandwiched between them. Two angel fish were embossed on pearlised paper – one with the stencil reversed – then both images were carefully cut out and stuck on either side of the tulle with spray adhesive. When the card is opened you have an embossed image on both the front and inside front faces. The bubbles were created using drops of a medium that is used for paper mosaics.

Some dark coloured papers show up the embossing much better than others – so, before starting any project on dark paper, experiment on a scrap piece first to ensure that the embossed images are clearly visible.

I have always been interested in Egyptology, and I was delighted when I found a multi-image stencil with an Egyptian theme. I could not resist incorporating this wonderful scarab beetle, embossed on matte gold paper, into a card design. The beetle was greatly revered by the Ancient Egyptians and is shown pushing the sun (exactly as depicted in wall paintings in the pyramids). However, he is actually a dung beetle, and you can guess what he really pushes along!

Both of the cards on this page were embossed on gold metallic paper using a single themed stencil that has three images – a Japanese lady, a border and a fan. The embossed images were then layered on to a contrasting card paper. A decorative Italian art paper, with a floral design in complementary colours, was used for the border. A gold pen was used to outline the border.

Metallic paper is fun to use, but you do have to be extra careful when embossing it – it is very thin and can tear if you are too heavy handed. Practise the lighter pressure needed on scrap pieces of metallic paper before working on the actual card.

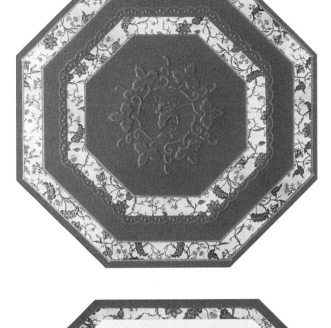

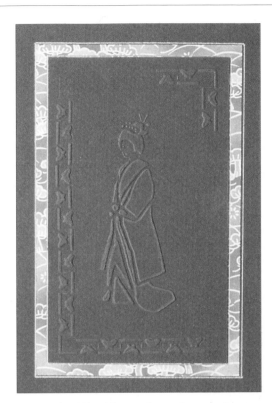

This blue card uses the same Japanese stencil as the other designs on these pages, but this time I reversed the stencil for the lady. A simple decorative paper border was layered between the embossed image and the card.

The two octagonal cards on this page also feature parts of the Japanese stencil, together with motifs taken from other stencils. The layered fans on the bottom card were embossed on a matte gold paper, then embellished with a sepia felt-tip pen.

Embossing metal

I love working with metal and wire, and I have found it possible to use stencils to create a repoussé effect on metal and tooling foil. Although these materials are called foil they are in fact thin sheets of metal, and they are available in gold, brass, copper and silver. Metal does not respond to embossing tools in the same way as paper – rather than just run round the outline of shapes, you have to work the tool over the whole area of each cutout. A large plastic embossing tool gives the best results, but you will have to use metal tools for some of the finer details. Take care when pushing out large areas; start with a gentle rubbing action, then gradually add more pressure to build up the area you need to raise.

I have included two projects in this chapter. The first one shows you how to emboss on metal with bought stencils, and how to use one of them to create a decorative, papercut mask. The second project shows you how to cut an acetate stencil from your own design, then how to use it to make an embossed picture frame.

Embossed metal card

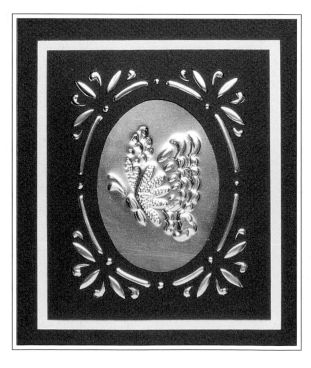

Two stencils are used for this card – a butterfly stencil for the central motif and a border stencil. The border stencil is also used to make a papercut mask overlay. For this type of work prepare a detailed plan on tracing paper.

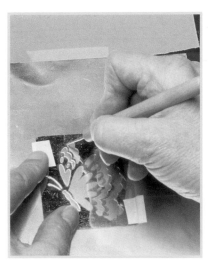

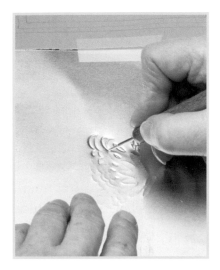

1. Create a plan on tracing paper, then use this to locate the central butterfly stencil on the metal. Secure the stencil to the metal with masking tape.

2. Place the metal and stencil on the embossing mat, then use a fine embossing tool to lightly impress *all* the outlines of the butterfly into the metal.

3. Turn the metal (with the stencil still attached) over, then, using the impressed outlines as guides, use a medium embossing tool to start embossing the cameo parts of the design.

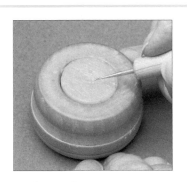

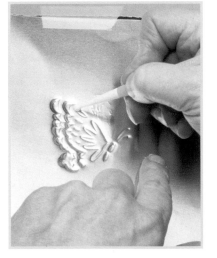

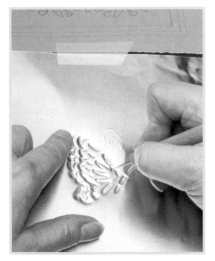

Reducing friction

When embossing on metal (and some types of paper), it is a good idea to wax metal embossing tools. This will help reduce friction and make the tools run smoothly over the surface. I use a small pot of beeswax.

4. Use a large plastic embossing tool to create a roundness across each embossed area. Gradually increase the applied pressure, and try to build up smooth rounded shapes.

5. Use a fine embossing tool to stipple round the outline of the inner wing, then work stippled texture into the enclosed area. This completes the cameo part of the butterfly design.

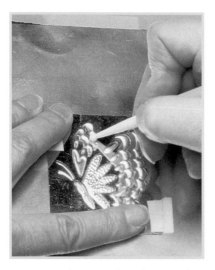

6. Turn the metal and stencil over, then use the large plastic embossing tool to work the intaglio parts of the design through the stencil. Use the fine metal tool to stipple the area of wing near the body.

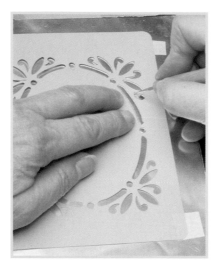

7. Use the techniques described in steps 1–4 to emboss the border design around the butterfly. This completes the metal embossing.

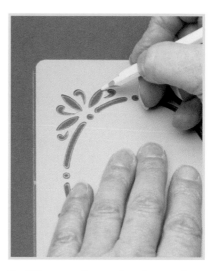

8. Now work up the decorative paper mask. Use a sharp white pencil to trace the border design on to a sheet of dark paper. Remove the stencil, then draw a smaller oval within the border.

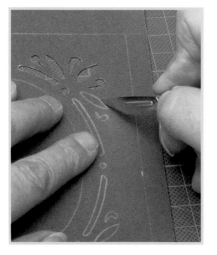

9. Use a craft knife to cut out the small parts of the design.

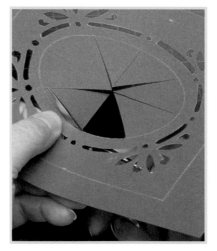

10. Use a sharp pair of scissors to cut out the centre oval. I find it best to work from the underside of the paper.

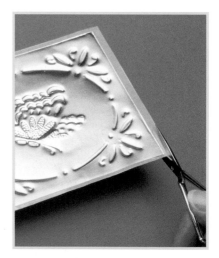

11. Cut the embossed metal to size, apply a thin strip of double-sided sticky tape round the edge, trim off any excess, then secure the metal to the card. Finally, secure the paper-cut mask in a similar way.

Picture frame

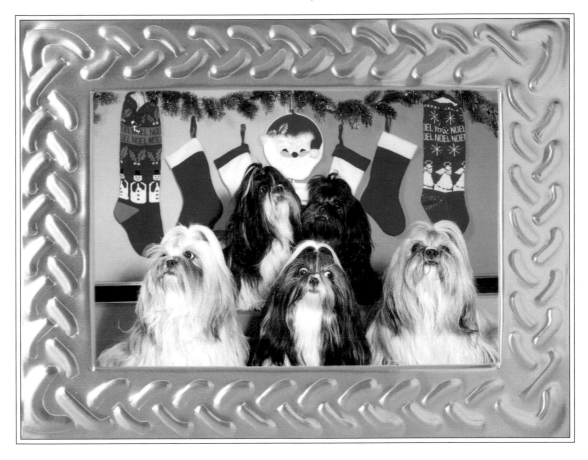

You do not have to restrict your embossing skills to making cards and bookmarks – picture frames can also be decorated with embossed designs, and metal is a great material to use for them. Blank frames can be purchased from craft shops, but it is easy to make them out of mountboard.

Up until now, only normal stencils have been used, but you can use an electric stencil cutter and a sheet of acetate to make your own stencils. Use coloured acetate so that the areas to be cut out are visible against the metal. Work up a design freehand or on a computer; keep it simple and make the cutouts relatively large (especially important when embossing on metal). You will also find it useful to block in the areas to be cut.

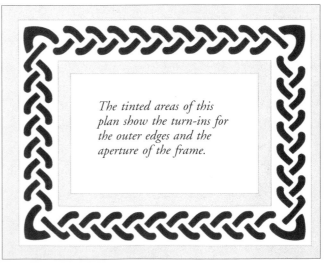

The tinted areas of this plan show the turn-ins for the outer edges and the aperture of the frame.

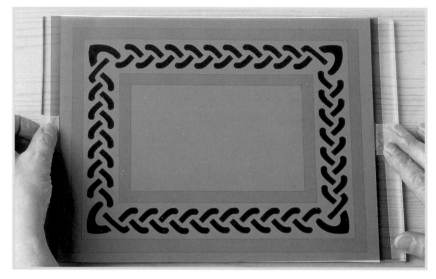

1. Create a plan for the stencil (including the turn-ins for the inside and outside edges of the frame), then secure it on top of a sheet of thick glass. Secure a sheet of coloured acetate on top of the plan.

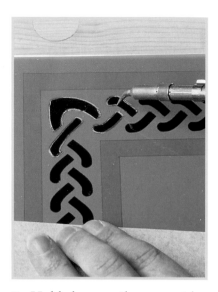

2. Hold the stencil cutter with its tip just touching the acetate, then carefully trace round the edge of each part of the design.

Cleaning the stencil cutter

Always keep the point of the stencil cutter clean. Remove any residual acetate by wiping the tip of the cutter on an emery board.

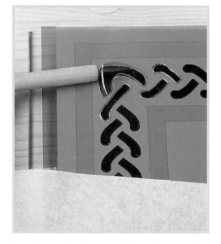

3. Use the fine embossing tool to lift out each cut segment. Do not pull/tear any partially-cut segments – if a piece does not lift out easily, use the stencil cutter to cut it again.

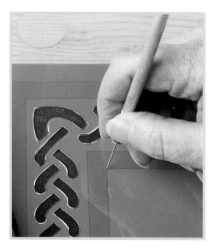

4. When all segments of the design have been cut out, transfer the stencil and plan to the embossing mat. Use a needle tool to pierce register holes in the corners of the plan.

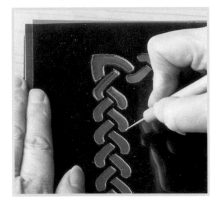

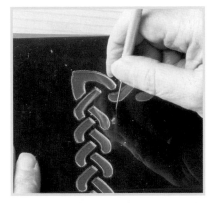

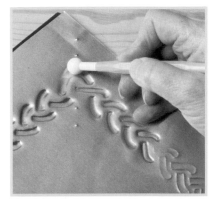

5. Secure the stencil to the metal, then use a fine embossing tool to outline the design.

6. Use the needle tool to transfer the corner register marks on to the metal.

7. Turn the metal (with the stencil still attached) over, then use a large plastic embossing tool to work the outlined areas.

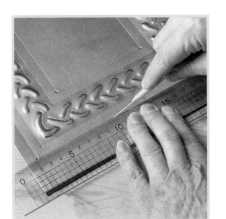

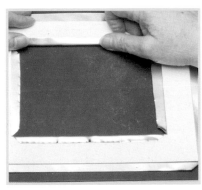

9. Cut away the excess metal round the outer edge of the design and from the centre. Place the embossed metal face down on the embossing mat. Position the card frame on top, then carefully fold the inner edges of the metal frame round the aperture. Mitre the outer corners, then fold them in.

8. Turn the metal over, remove the stencil then use the needle tool to lightly score lines between the corner registers.

10. Cover the metal edges on one short side with masking tape (this will be the opening for the insert). Cover the edges on the other three sides with double-sided sticky tape, then secure the embossed frame to the backing board.

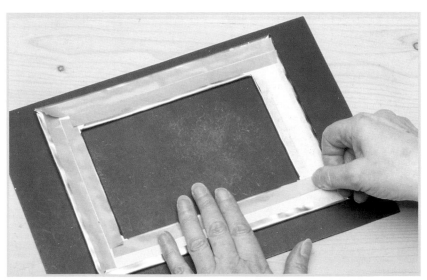

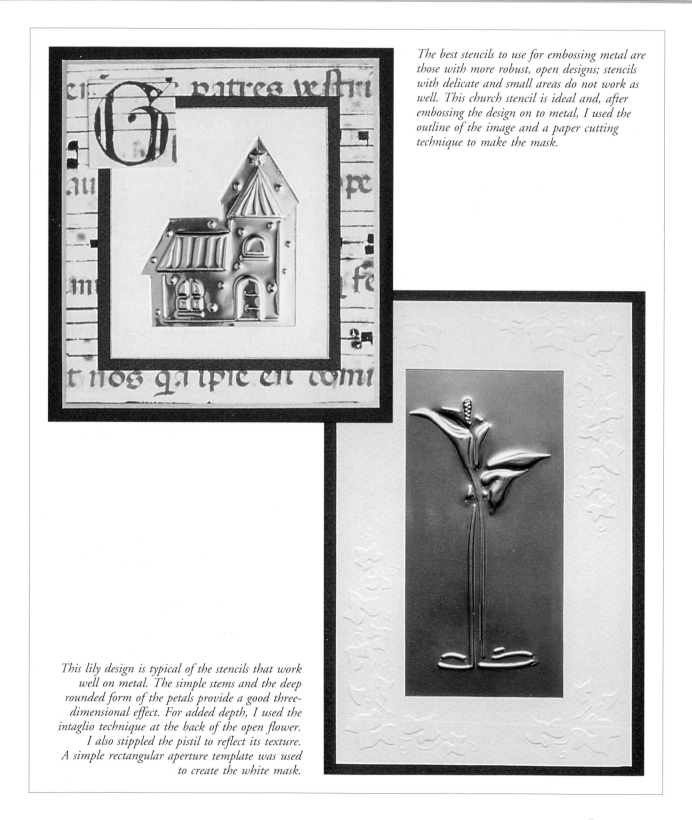

The best stencils to use for embossing metal are those with more robust, open designs; stencils with delicate and small areas do not work as well. This church stencil is ideal and, after embossing the design on to metal, I used the outline of the image and a paper cutting technique to make the mask.

This lily design is typical of the stencils that work well on metal. The simple stems and the deep rounded form of the petals provide a good three-dimensional effect. For added depth, I used the intaglio technique at the back of the open flower. I also stippled the pistil to reflect its texture. A simple rectangular aperture template was used to create the white mask.

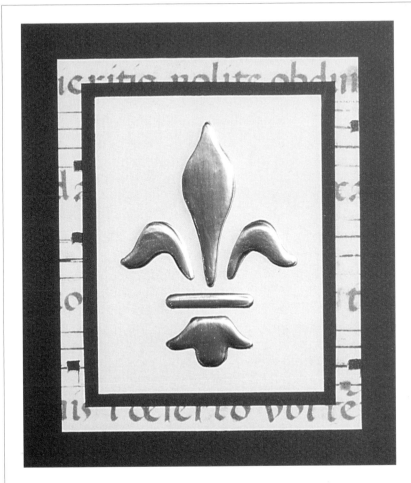

This is another example of using stencils for embossing and paper cutting. The fleur-de-lis image is part of a wall stencil but you can see how well it lends itself to card making. I embossed the image on to copper foil, cut a mask out of white paper, then layered them together with a decorative art paper. The small image above is the same design worked in dark opaque paper.

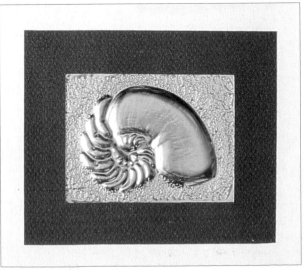

The background for this Nautilus shell card was stippled from the front of the foil. This process took rather a long time to complete, but it was well worth the effort as it produces the hammered effect that is so much part of repoussé work. Again, I used a rectangular aperture template to cut the mask.

Fancy-edged rulers

In recent years there has been an upsurge in products aimed specifically for the memory book market. Fancy-edged rulers and aperture templates of all shapes and sizes can be found in many retail outlets. However, you can also use them – either on their own or in conjunction with regular stencils – to produce some really great embossed designs!

Fancy-edged card

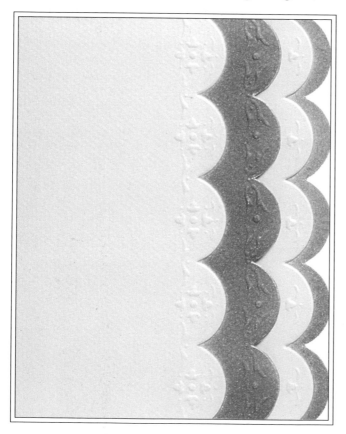

In this last project I show you how effective fancy-edged rulers can be. I also show you how to use a sponge and dye ink pads (normally used by rubber stampers) to introduce colour to an embossed design.

For this design, the front face of the card is cut along the right-hand edge of the wide blue band.

 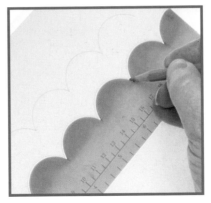 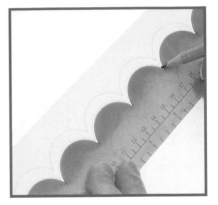

1. Draw a plan of the design and mark the proposed fold edge with a dashed line. Secure the plan (face down) on the lightbox.

2. Place the card paper (face down) over the plan and align its fold edge with the dashed line on the plan. Use the ruler to trace the inner two lines on to the inside front of the card.

3. Turn the card paper over, realign its fold edge with the dashed line on the plan, then transfer the outer two lines on to the back of the card.

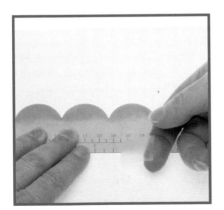

4. Remove the plan, then secure the card paper (face up) on the lightbox. Align the ruler against the inner of the two lines on the front of the card and secure with low-tack tape.

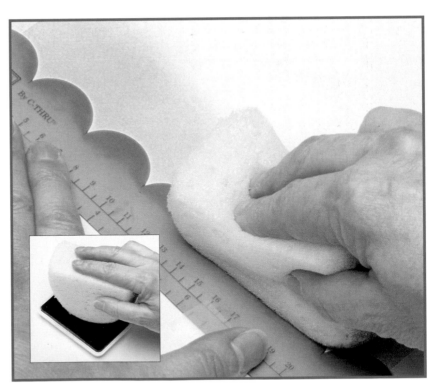

5. Load a sponge with colour by dabbing it several times on the ink pad, then dab the loaded sponge over the exposed edge of the front of the card. Continue loading the sponge and adding colour until you achieve the desired tone.

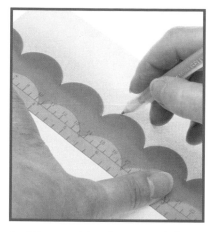

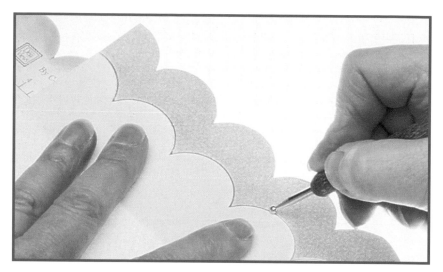

6. Use a gold gel pen to define the inner edge of colour. Remove the ruler and clean it with a paper tissue. Align it with the line for the outer edge of the card, then define this edge with the gold pen.

7. Cut along the outer edge of the front of the card to leave the gold line. Secure the ruler to the lightbox, place the front of the card (face up) over the ruler and carefully align the inner gold line with the edge of the ruler. Run a large embossing tool along the edge to lower the blue band.

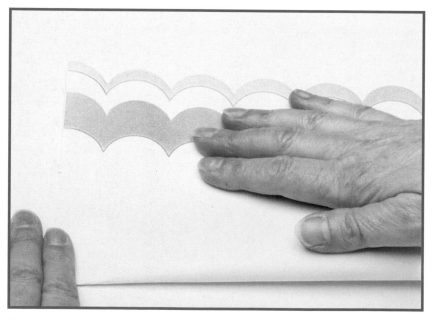

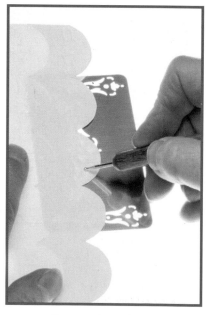

8. Repeat steps 4–7 on the inside back of the card. Fold the card and align the decorative edges, then make a short crease at the top and bottom (you may have to slightly adjust the original fold line). Score and crease the fold, then use a set square to trim the top and bottom of the card.

9. Finally, working from the inside front and then the back of the card, emboss small motifs to both the coloured and plain parts of the card.

The design for this simple yet effective card was created using the same fancy-edged ruler as the project on pages 42–44 in combination with the stencil used for the intaglio project on pages 18–20. Working with the ruler under the front face of the card, I embossed the inner scalloped lines first, moved the ruler back slightly, then embossed the outer lines. I turned the card paper over, then added all the cameo motifs.

I worked this cameo embossing on a strip of card paper, then layered it with a contrasting plain border. I started by embossing the inner line on one side of the design, then moved the paper slightly to create a multiple image of the ruler edge. I then flipped the ruler over and repeated the embossing on the other side. The addition of small detail motifs adds a touch of elegance.

I have included this card, with simple embossing, as it shows how you can use fancy-edged rulers to create decorative embellishments. I embossed the top and bottom motifs straight on the card paper and the middle one on a separate piece of paper. I used a gold gel pen to trace an outline round the middle motif and the round-cornered border (the outer edge of the stencil). I used a fancy-edged ruler and the gold gel pen to make the scalloped diagonal strip, then layered everything together with a strip cut from a sheet of decorative paper.

This bookmark is another example of how versatile fancy-edged rulers can be. I coloured the outer edges with a sponge and a red dye ink pad (see page 43) then I worked up the embossed design in a similar way to the card on page 45.

Moving on

In a small book it is impossible to show every method of using stencils. However, I have introduced you to the basic techniques of stencil embossing on different surfaces, and it is now up to you to explore the full potential of this art form. The photograph below shows just a few of the many other items you can make. You can cover boxes with embossed paper, mount your embossed images on translucent paper, or combine embossing with other papercraft techniques. You can do all sorts of things, so go on, let your creativity take wings.

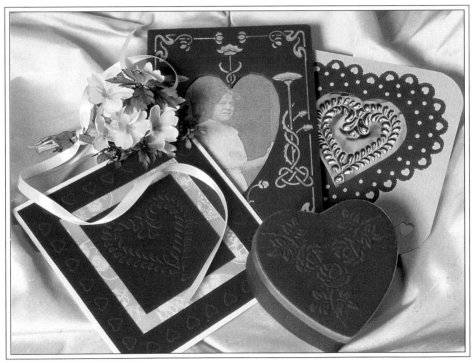

The picture frame was embossed from two stencils, one of which was used for the cards shown on pages 16 and 22.

A paper pricking technique and fancy paper punches were used to create the border round the metal heart card.

The Valentine card was embossed on opaque paper then layered on to decorative translucent paper.

A single-rose stencil was used to emboss the three roses on the heart-shaped box – I had to plan this design carefully to make it fit the blank box.

Index

bookmarks 20, 21, 46
boxes 47

cards 10–36, 40–46
corner borders 22–27
craft knife 9, 29–30, 36

designs *see also* plans 10, 11, 22, 24, 29
dye ink pad 9, 15, 17, 26, 42, 43, 46

intaglio images 18–21, 27, 36, 40, 45

labels 17
lightbox 8, 12–13, 19, 23, 29, 43

mat, embossing 8, 28–29, 35, 38–39

materials 6–9
metal foil 6, 34–41, 47

paper
 decorative 6, 9, 14–15, 32–33, 41, 46, 47
 embossing 6
 metallic 6, 17, 24, 26, 31, 32–33
 opaque 28–33, 41
 pastel 6
 pearlised 31
 velvet 6, 17
picture frame 34, 37–39, 47
plans 10–11, 19–20, 22–23, 24–25, 26, 27, 28, 34–35, 37–38, 42–43

repeat patterns 18–19, 28–29
rubber stamps 26
rulers, fancy-edged 8, 42–46

scissors 9, 36, fancy-edged 9, 20, 21
stencils
 cleaning 11
 cutting 7, 34, 37–38

techniques, other
 layering 6, 9, 14, 23, 25, 26, 29, 32
 paper cutting 34, 36, 40, 41
 paper pricking 47
tools 7, 12–14, 19, 23, 29, 34, 35–36, 38–39, 44